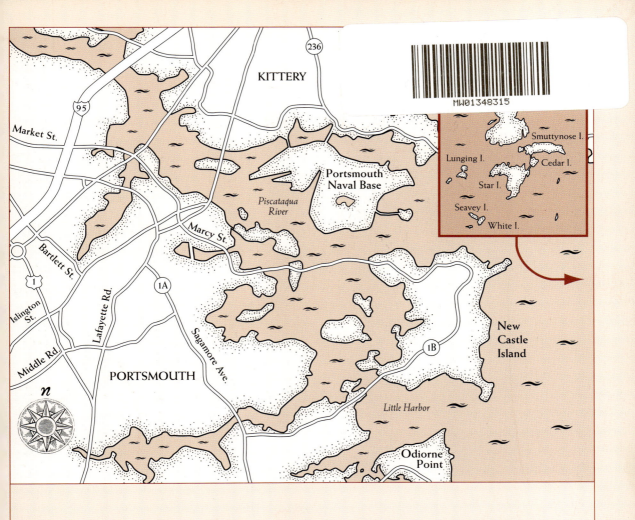

Portsmouth, New Hampshire

Copyright © 2010 by Nancy Grace Horton.

All rights reserved. No part of this book may be reproduced in any form or by any electronic or mechanical means without permission in writing from the publisher, except by a reviewer who may quote brief passages in a review.

ISBN 10: 0-615360-51-3
ISBN 13: 978-0-615-36051-5

Cover and interior design by Peter Blaiwas, Vern Associates, Inc.
Printed in South Korea.

Published by Polka Dot Productions
P.O. Box 41
Portsmouth, NH 03802 USA

Images from this book are available through www.hortonphoto.com.

Inquires: ngh@hortonphoto.com.

Portsmouth

PHOTOGRAPHS BY NANCY GRACE HORTON

Text by Laura Pope

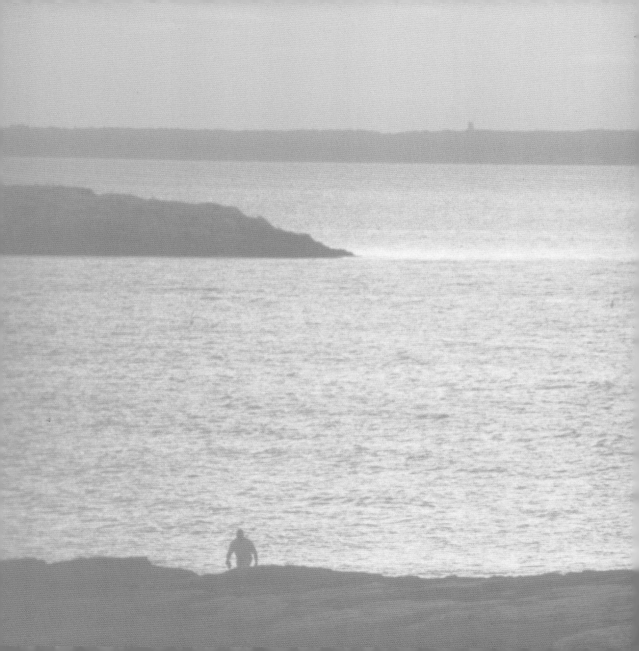

Just over a dozen miles in length, the Atlantic coast of New Hampshire has a long and fascinating pedigree. Unlike much of the state, which geologists believe developed from a group of tropical islands once located several hundred miles south of the equator, the coastal lowlands were torn from what was once part of the African continent. A mighty, deep river called the Piscataqua—the confluence of six major and many minor rivers—flows east toward the Atlantic, separating the states of New Hampshire and Maine. It is this tidal waterway close to the sea, and the abundance of natural resources in it and on its shores, that lured explorers and traders, fishermen and sea captains to Portsmouth, the state's sole port.

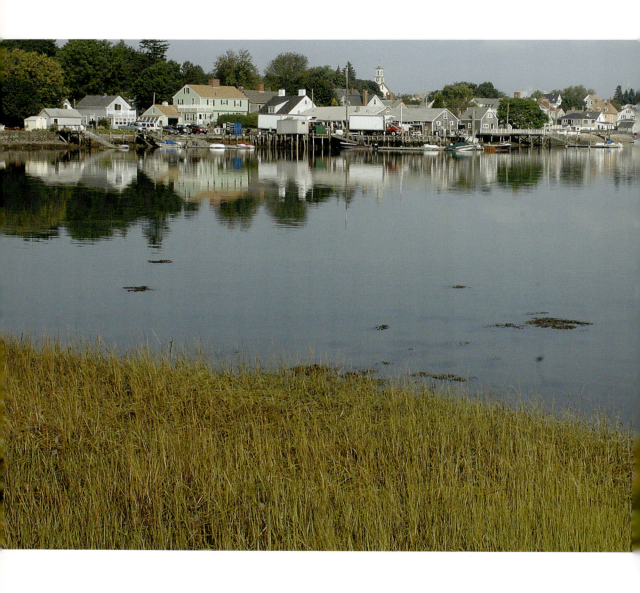

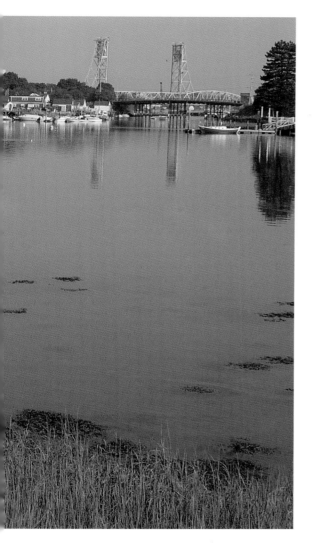

(*overleaf*) Isles of Shoals at sunset

THERE IS A TIDAL RIVER THAT FLOWS into the Atlantic Ocean; it is deep and wide. The currents are swift and strong. The shore is rocky at the edge. And in the springtime, years and years ago, the banks were covered with ripe, red strawberries.

—Elaine MacMann Willoughby,
The Story of Strawbery Banke in Portsmouth, New Hampshire, 1970

Along the Piscataqua River, South End

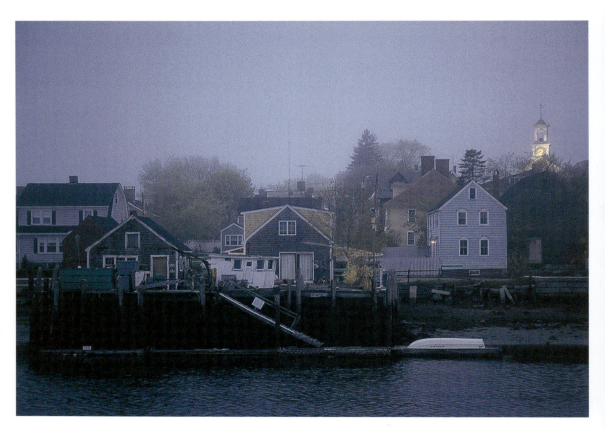

Foggy view of South End

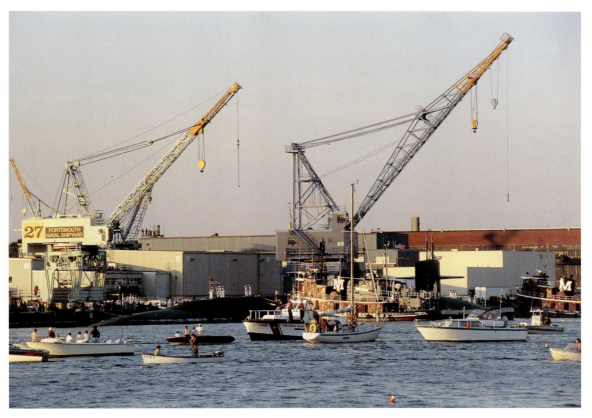

The Portsmouth Navy Shipyard from Prescott Park

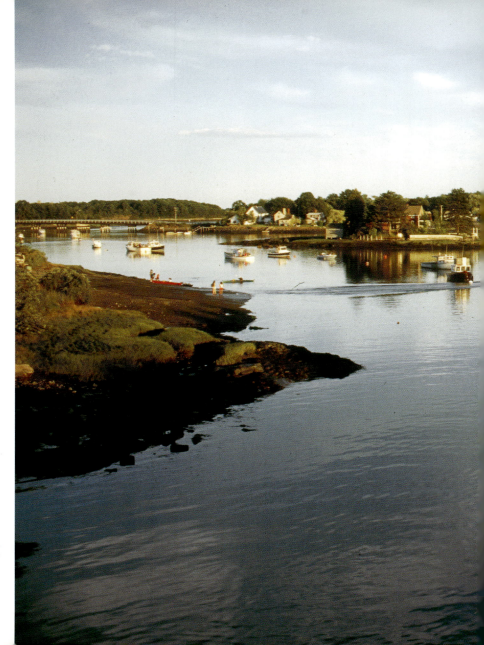

Portsmouth harbor channel

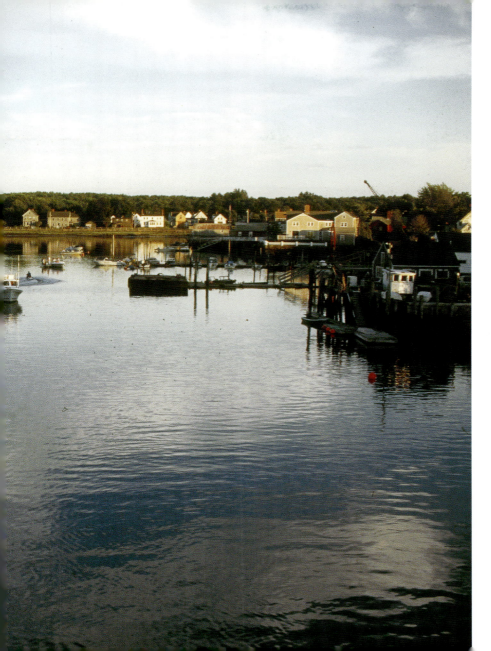

Viking adventurers were probably the first foreigners to set eyes upon the coast of New Hampshire. That was around 1000 A.D. Explorer John Cabot's foray to the North American continent in 1497 started a steady trickle of expeditions by other Europeans intent on exploring the New World and reaping its riches.

Among the first to record the bounty of the Piscataqua, its islands, and the seashore was Martin Pring of Bristol, England, who found and navigated the river in 1603. Later, in 1614, Captain John Smith sailed and mapped the New England coast following Pring's notes.

From the most important seaport in all of England, the city of Plymouth in Devonshire, came David Thomson, who had for years promoted the idea of

establishing a trading post or plantation near the rich fishing grounds of the Piscataqua River. Sponsored by three wealthy Plymouth merchants, Thomson sailed for New Hampshire in 1620 and soon thereafter built the first plantation, named Pannaway and later called Pascataqua, along the shoreline in Rye on Odiorne Point.

Other captains would follow, financed by English merchants with a nose for enterprise, and soon a Great House was built at Strawbery Banke, the name given to Portsmouth by its first settlers in honor of the red fruit growing wild on the riverbanks. Captain John Mason of Portsmouth, England, claimed New Hampshire as a British settlement in 1629.

(*overleaf*) South Mill Pond with City Hall complex in background

OUR HARBOR IS AS WELL CALCULATED FOR navigation and our rivers for shipbuilding as any perhaps in the United States, which the genius of our people also favour.

—Joseph Whipple, Federal Collector for
 U.S. Customs District of Portsmouth, 1789

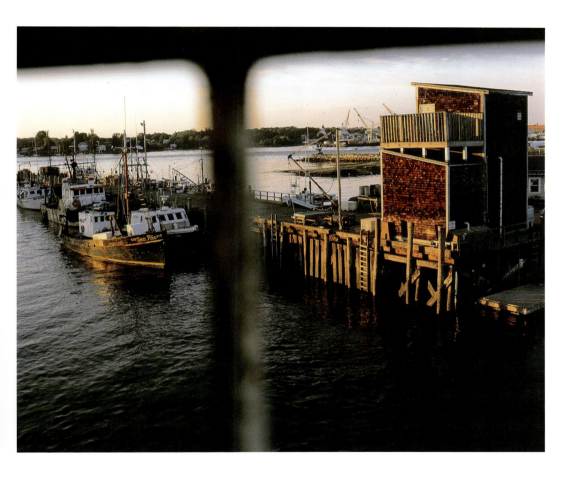

Fishermen's Co-op from the bridge to Four Tree Island

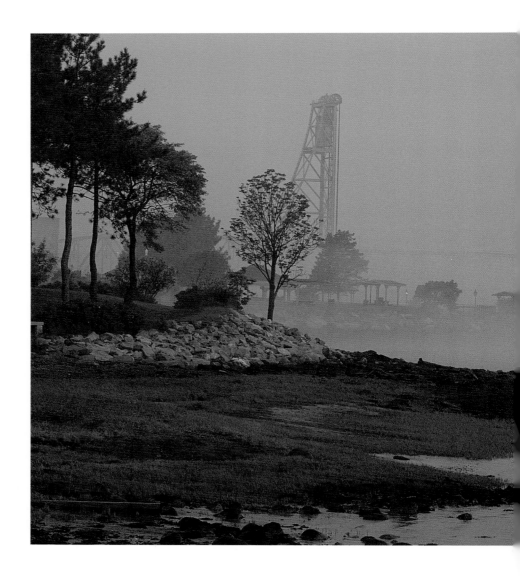

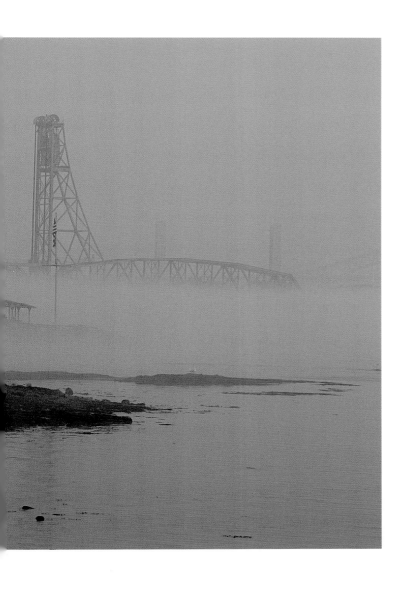

Memorial Bridge and Sarah Mildred Long Bridge from Four Tree Island

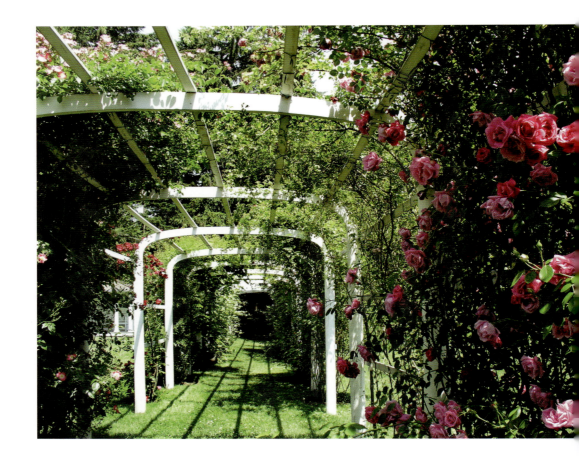

Captain John Langdon House rose arbor

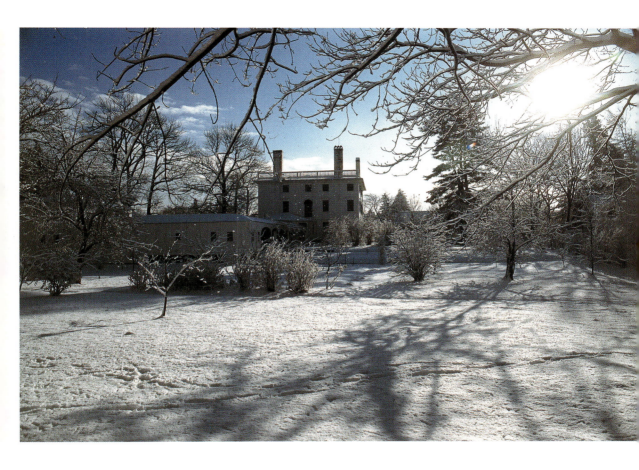

Rundlet-May house in winter

PORTSMOUTH IS A GEM, a microcosm, a living illustration of New England coastal history.

—*New York Times*, June 2, 2002

Children play along the shore at the Wentworth Coolidge Mansion

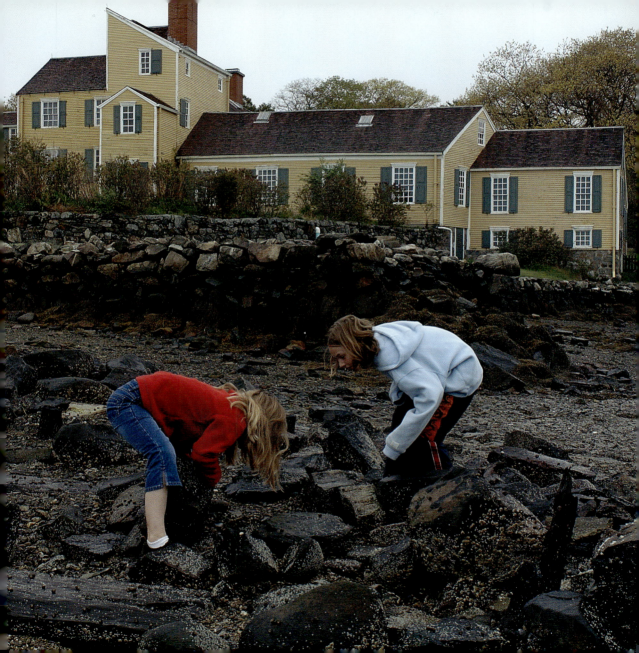

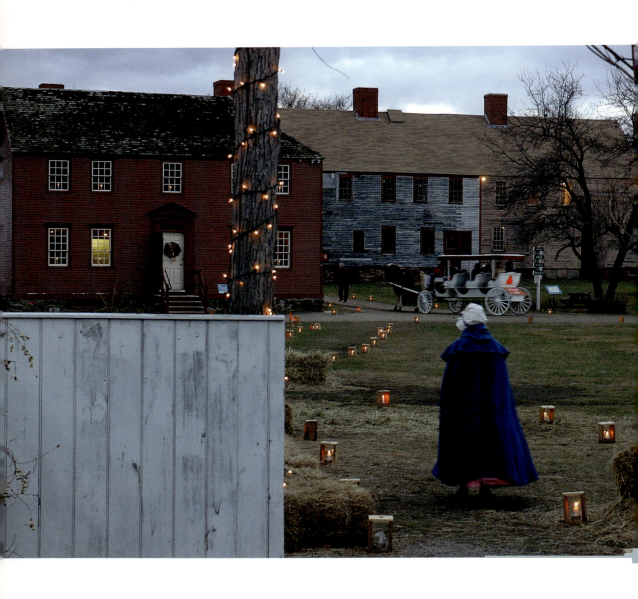

FEW PLACES ARE AS RICH IN COLONIAL atmosphere as Portsmouth, New Hampshire which, with Charleston and Annapolis, is one of the rare American cities to retain its character as a proud, patrician, pre-Revolutionary seaport.

—Samuel Chamberlain,
Portsmouth New Hampshire: A Camera Impression, 1940

Candlelight Stroll at Strawbery Banke Museum

Portsmouth is an ideally located, resource-rich river city and its earliest European settlers were lured more by commerce than by religious freedom. Island-studded and ringed by pine and oak forests, Portsmouth harbor offered quick access to the rich fishing grounds located just a few miles from the mouth of the river at the Isles of Shoals. The sources of the settlers' prosperity were protected by fortifications on both sides of the river from the harbor to the coast. Ferries shuttled townsfolk across the river noted for its treacherous currents. Today, three bridges of varying size and vintage span the shipping canal connecting Portsmouth to Kittery, Maine.

Location was, and remains, one of Portsmouth's trump cards. As the new city took hold, sawyers mills sprang into action up and down the river along the Piscataqua's tidal basin, supplying wood for the construction of ships, stately homes, and furnishings. A prosperous merchant class demanded the very best

homes—broad-shouldered, elegant, and ornate—built by a cadre of English- and native-born carpenters and joiners.

Wide avenues in the south and north ends as well as downtown squares of the provincial city were lined with grand houses of the Georgian and, later, Federal and Greek Revival periods. Narrow streets were filled with the more meager homes of ordinary folk. Wharves and warehouses jutted from these neighborhoods into the life-giving river; a few survive to this day.

Though Portsmouth has been lauded as one of only three cities with vast, intact tracts of Georgian era architecture, a series of great fires changed the landscape and destroyed the earliest structures. Most devastating was the Great Fire of 1813. Many of the city's brick structures were built after this catastrophe.

(*overleaf*) The Sarah Long and Route 95 bridges viewed from St. John's Church

WITH A GOOD HARBOR ON THE BROAD AND DEEP Piscataqua River, the development of a wide and fertile surrounding countryside and unlimited fine timber for ship building, [Portsmouth] soon became an important port.

—William Lawrence Bottomley, *Methods of Designing and Construction of Our Early Days*, 1965

An aerial view of Portsmouth and waterways

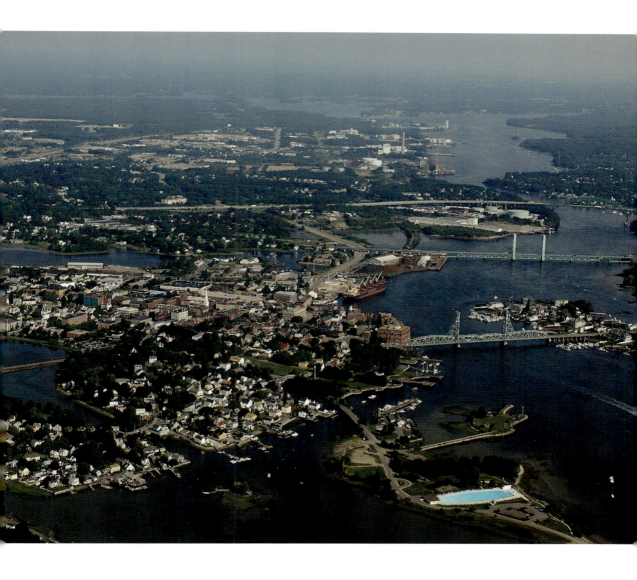

TO SIT IN HAPPY INDOLENCE,
To rest upon the oars,
And catch the heavy earthy scents
That blow from summer shores;

—Thomas Bailey Aldrich,
 from "Piscataqua River," 1865

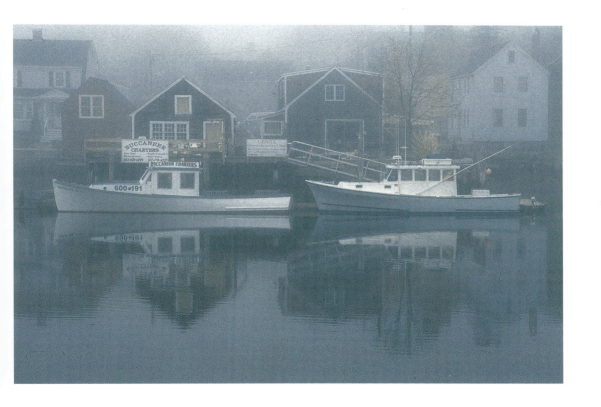

Boats at port in the South End

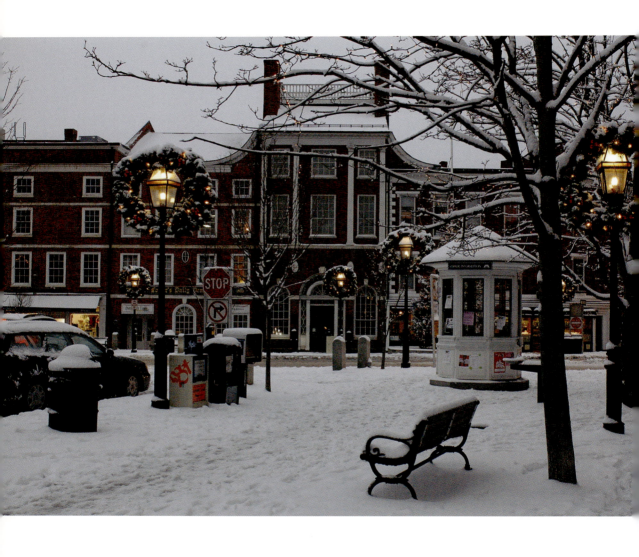

THE OLD HOUSES CROWD CLOSE TOGETHER STILL
As if trying to keep warm
And the winds that blow through Old Portsmouth Town
Still rattle the sails of the boats in the storm

—Harvey Reid, from "Old Portsmouth Town," 1984

The Athenaeum and Market Square in winter

30

WRAPPED IN A SILKEN CLOAK OF WINTER WHITE
I can see your breath in the Cate Street light
In the Old Port

In the Old Port
Winter tears dance down rocks and terrain
Swirling at your feet in the cobble drain
In the Old Port

Salt and woodsmoke air
In the dusty light
Pisces rising just offshore
In a whisper to this fragile night
We meet in the Old Port

—Tom Richter, from "The Old Port," 1990

Sea fog drapes the river in winter

WE THINK OF CULTURAL TOURISM AS SOMETHING WE INVENTED, but it has always been an economic driver for Portsmouth.

—Maryellen Burke on Portsmouth painter-poet Sarah Haven Foster, who penned a self-guided tour book filled with her watercolors of Portsmouth neighborhoods in 1867

Wentworth by the Sea, New Castle, New Hampshire

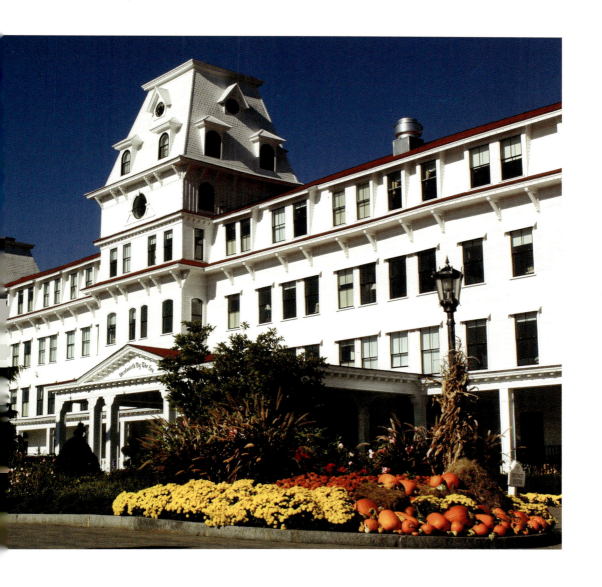

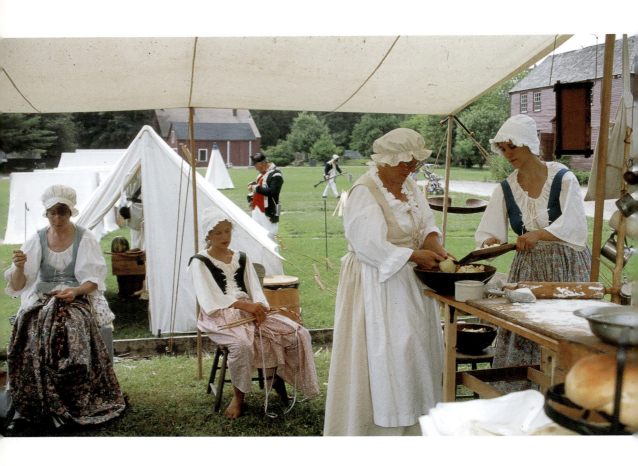
Re-enactment and encampment at Strawbery Banke Museum

PORTSMOUTH WAS THROUGHOUT THE COLONIZING period and up to the Revolutionary War, one of the most important seaports of the British colonies in the new world. Its shipbuilding and shipping interests were extensive for the times, and it was the residence of the royal governors of the province of New Hampshire up to the time the royal authority was defied and overthrown.

—*Illustrated Memories of Portsmouth, Isles of Shoals, New Castle, York Harbor, York Beach, and Rye, New Hampshire,* 1900

To understand Portsmouth's true nature is to appreciate how her plentiful natural resources and prime geographical location, leveraged by talented tradesmen and savvy merchant captains, resulted in an extraordinary, bustling metropolis. Gargantuan ships built for trans-Atlantic trade, as well as the flat-bottomed local barges called gundalows, skimmed the river's lanes laden with stores both mundane and exotic, lining the pockets of many prominent families.

Streets and homes bearing the names Wentworth, Whipple, Sherburne, Penhallow, Chase, Langdon, Wibird, and Amazeen recall Portsmouth's early commercial visionaries, renowned for turning opportunity into wealth and privilege. Some of that wealth was accrued through savory imports such as rum, molasses, and spice, or amassed by the sale of timber or bricks from the many local brickyards.

Another source of commercial success was privateering, a lucrative and opportunistic practice that licensed captains of private ships outfitted specifically

for the capture of enemy ships during wartime. The slave trade was another. One year before the Revolution, a Portsmouth census revealed the presence of 140 slaves in the city. Today, the Black Heritage Trail documents the impact of this practice and details the lives of African-Americans living in the provincial outpost.

The attributes that attracted the first settlers to the region also caught the attention of the young nation's Department of the Navy. Islands in the harbor were purchased and what is now the nation's oldest navy yard was established in an area rife with talented shipwrights and independently-owned shipyards. The only U.S. submarine to see action in World War I was constructed at the Portsmouth Shipyard in 1914. The shipyard was a heavily guarded submarine manufacturing center during World War II and continues to play a critical role in maintaining the U.S. submarine fleet. Albacore Park, featuring a submarine exhibit and museum, pays homage to Portsmouth's key role in refitting, repairing and testing the nation's submarine fleets.

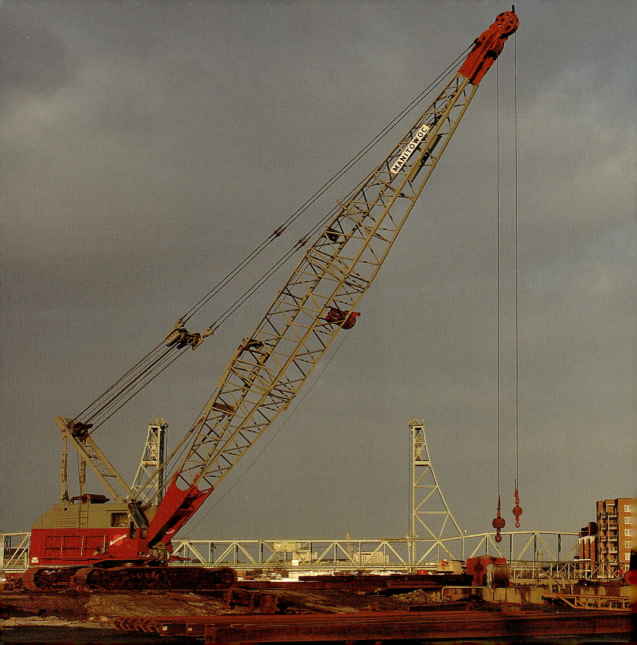

(*overleaf*) View from Memorial Bridge

Portsmouth remains a working port with
Memorial Bridge, waterfront and Shipyard

I KNOW A GENTLE RILL

That springs beside a hill,

In the shade

Of the birch's emerald screen,

And the alder's cheerful green,

And the sweet-fern in between,

Where the sun's bright glow, I ween,

Ne'er hath strayed

—B. P. Shillaber,
 from "The Little Rivulet," 1865

Prescott Park in bloom

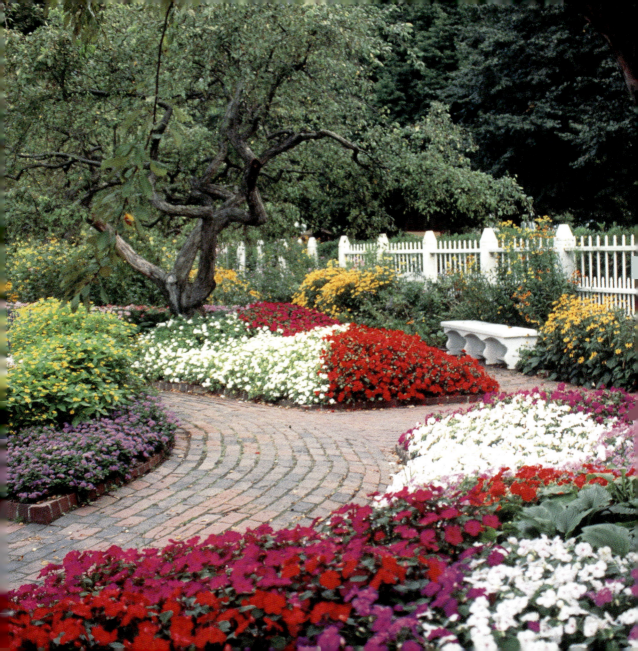

THE OPENING OF THE [MEMORIAL] BRIDGE was really the opening of downtown Portsmouth.

—Former Portsmouth mayor Eileen Foley who, in 1923, at age five, cut a pink silk ribbon to open the bridge

The oldest bridge, Memorial Bridge, shrouded in fog

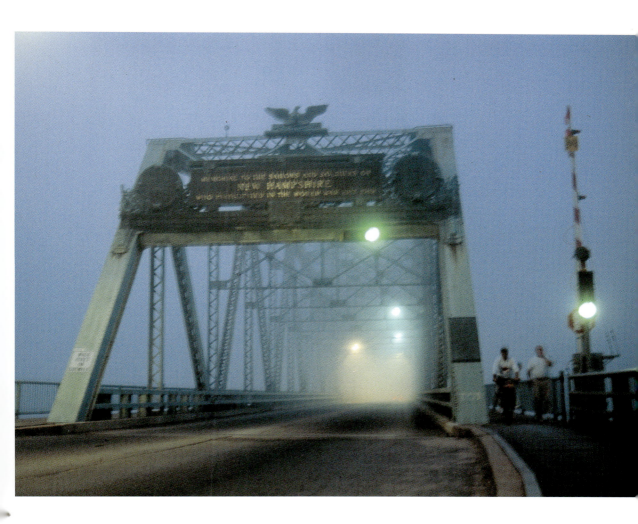

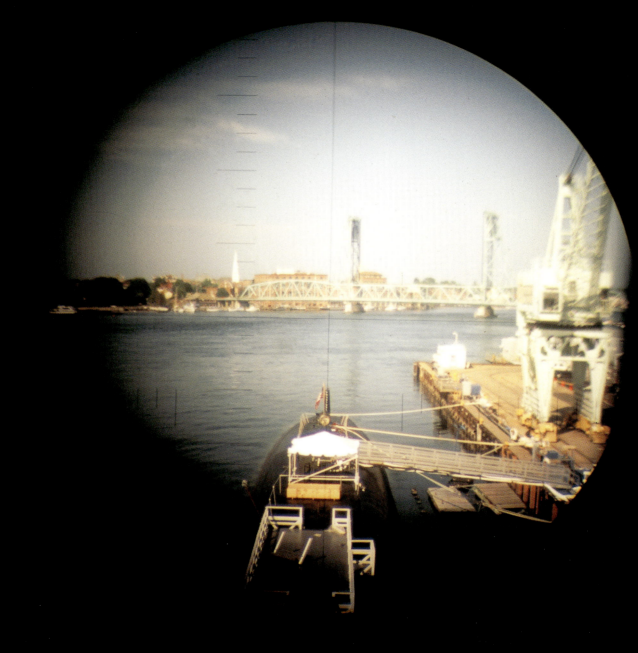

HAVING MADE PREVIOUS PREPARATIONS FOR IT, about 8 o'clock, attended by the President, Mr. Langdon and some other gentlemen, I went in a boat to view the harbour of Portsmouth; which is well secured against all winds; and from its narrow entrance from the Sea and passage up to the Town, may be perfectly guarded against any approach by water.

—George Washington, from his journal, 1789

From the inside of the USS *Maine* looking from the shipyard to the Memorial Bridge and downtown Portsmouth

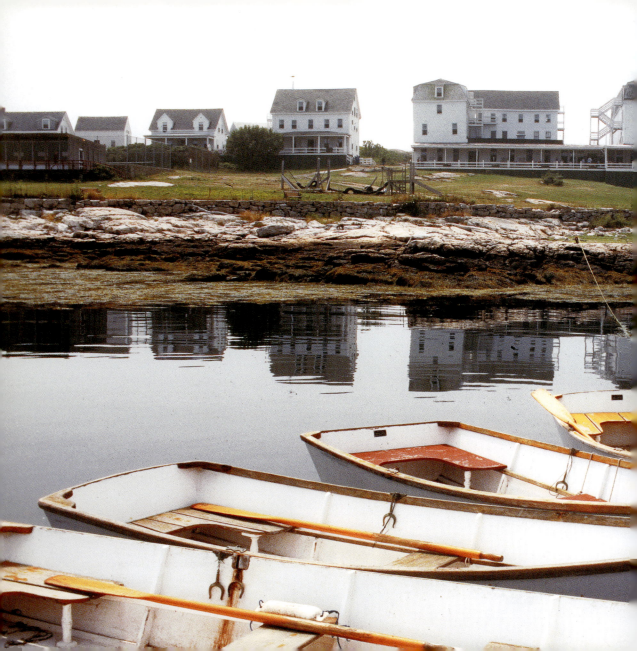

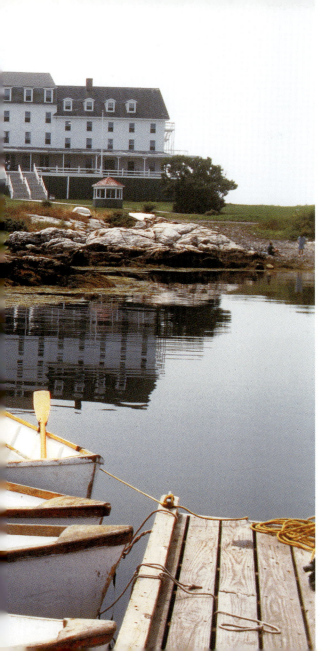

From the docks, looking at
Star Island, Isles of Shoals

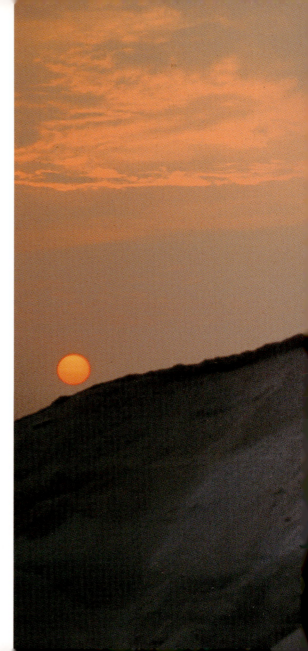

Sunset over salt piles

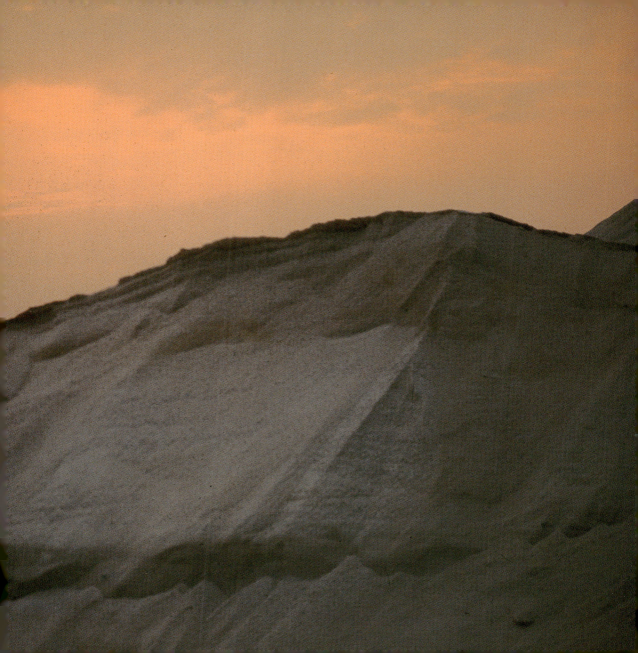

Portsmouth has hosted her fair share of famous residents and visitors. John Paul Jones came here as commander of the sloop of war *Ranger*. A wily nineteenth-century entrepreneur by the name of Frank Jones became a beer-making tycoon in a place that today boasts fine, micro-brewed beers.

President Theodore Roosevelt put Portsmouth on the international map when he engineered the Portsmouth Peace Treaty in 1905, ending the Russo-Japanese War and earning himself the Nobel Peace Prize.

Famed poets and authors Celia Laighton Thaxter and her cousin, Albert Laighton, were born in Portsmouth. Their legacy trickles down to passengers aboard the *Thomas Laighton*, a large pleasure boat named in honor of Celia's father, who is remembered for building the Appledore Hotel on one of the Isles. Another favorite son was author Thomas Bailey Aldrich, whose works and friendship greatly influenced Mark Twain.

In the coastal city wedged between Boston and Portland, arts and artists have had a vital, visible role that continues today. The ambitious, diverse programs of live performance staged by national and international ensembles at the Music Hall

begin each September with the prestigious Telluride by the Sea Film Festival, a sampler of independent films from around the world offered in collaboration with the Telluride Festival in Colorado.

The Prescott Park Arts Festival, the largest outdoor summer festival in New England, entertains thousands with an outdoor main stage musical, jazz and folk festivals, children's theater, a popular art show and special music series. Bequeathed to the city by the Prescott sisters, the park is adorned with formal and experimental gardens, water fountains, the Sheafe warehouse (now an art museum) and a restored Liberty Pole. Just steps away, a busy fisherman's co-op echoes an enduring, native livelihood.

One of the country's leading music destinations, the Press Room hosts a spectacular roster of emerging and established folk and jazz musicians in a British pub atmosphere.

Visual arts are given a high priority, too, and the city's ample galleries and public spaces exhibit a changing roster of artworks. One day each month, a self-guided Art Around Town tour gives art lovers a sampling of several galleries. Most recently, the city has earned enormous acclaim for its poets.

(*overleaf*) Frank Jones Brewery

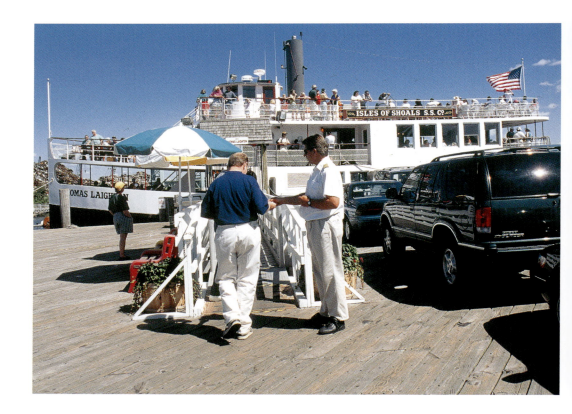

Isles of Shoals Steam Ship, the *Thomas Laighton*, with Captain Whittaker in foreground

LIKE AN AZURE VEIN FROM THE HEART OF THE MAIN,
Pulsing with joy for ever,
By verdurous isles, with dimpled smiles,
Floweth my native river;

Singing a song as it flows along,
Hushed by the Ice-king never;
For he strives in vain to clasp a chain
O'er thy fetterless heart, brave river!

—Albert Laighton, from "My Native River," 1865

THE STREETS WERE FORMALLY NAMED IN 1778. . . .
For example, do you know where the original Market Square was? The 1778 street description puts it in the Spring Hill area, around the junction of Bow, Ceres, and Market Streets. It was not until 1838 that the present Market Square was so called, and at that time the Board of Selectmen went through another ordeal of street naming.

—Ray Brighton, *They Came to Fish*, 1973

Market Square Day, downtown

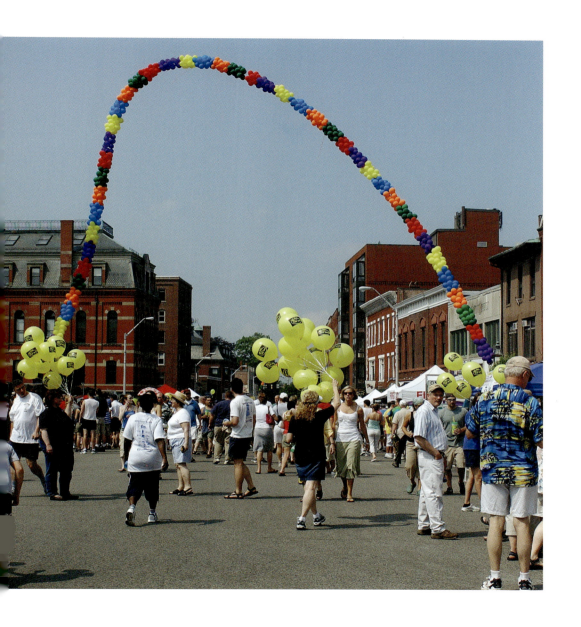

(*opposite*) Residential view in spring

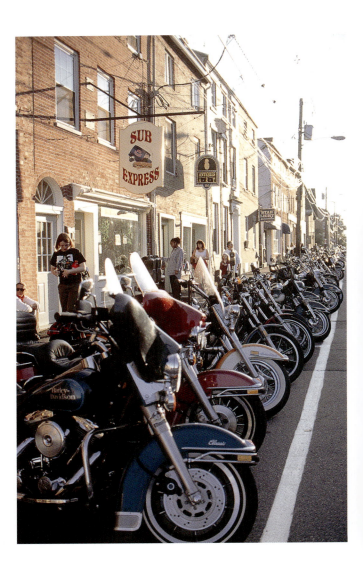

Summer on State Street

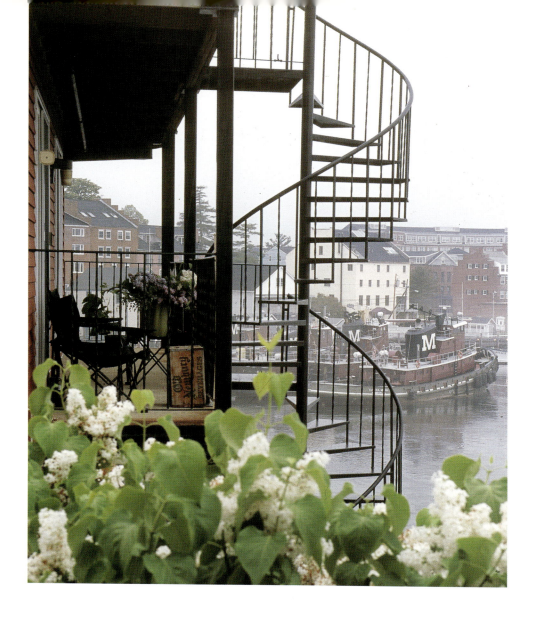

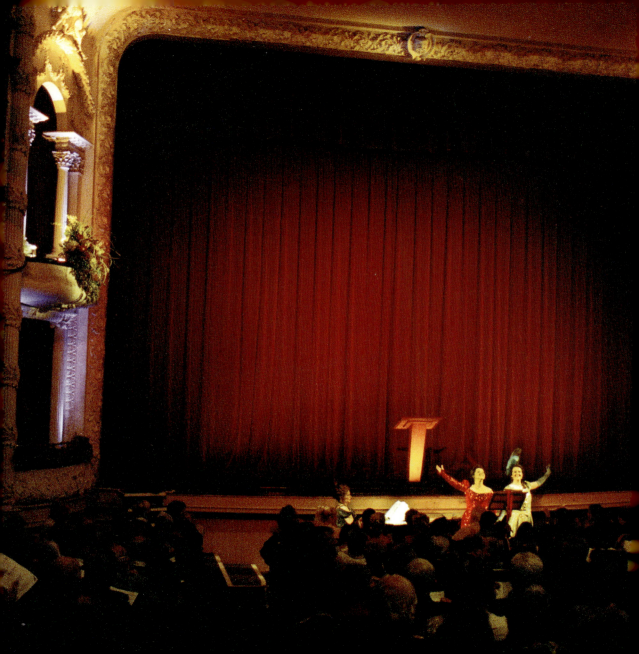

WE SHALL HOPE TO SEE THE NEW HALL FILLED at its opening, by an admiring and appreciative audience, who, while gazing at the beauteous surroundings and enjoying the cozy and comfortable auditorium, will congratulate themselves upon this important addition to the attractions of old Portsmouth.

—*Portsmouth Journal,* January 19, 1878, regarding the new Music Hall, ranked among the 15 oldest music/vaudeville houses in America today

Music Hall stage still sparkles

RUMORS

I hear you can tell the trees apart
by the sound of the wind in their branches:
The sighing of the pines is nothing
at all like the wind in the willows.
Elms in full foliage gently
rustle, aspen are easily rattled.
All under the leaves of life they tend:
Oaks to creak at a higher pitch
and maples more apt to tap
imperiously at your window.
And I have heard the news and so have you,
so let us talk of things indifferent.
And the wind will tell the trees apart
By the rumors passing through.

—Robert Dunn, 1985

Former Portsmouth Poet Laureate Robert Dunn

New residents and businesses are drawn to the newly remodeled, upscale city, which still depends on the riverside for much of its charm. Cherry red working tugboats hug the narrow lane called Ceres Street, lined with brick warehouses that once stockpiled ships' stores. Blocks of townhouses, stacked together and painted in a variety of colors, edge the thriving downtown retail business sector offering goods from haute couture and cuisine to hand- and locally-made furnishings, decorations and fashions.

Where merchant and war ships once sailed, vessels destined for whale watches and river excursions share the shipping lanes with tankers, pleasure craft, and Coast Guard cutters.

Private industry up and down the river added to the city's cache, and by the 1990s Portsmouth was a sister city to Carrickfergus, Northern Ireland; Portsmouth, England; Szolnok, Hungary; Parnu, Estonia; and Nango, Kitago and Nichinan, Japan.

The heart of the city, Market Square, anchored by the lofty spire of the North Church, brims with cafes, restaurants and specialty shops. In fair weather months, its sidewalks hum with visitors, here to sample the culture, enterprise, and history that make Portsmouth the resilient river city by the sea.

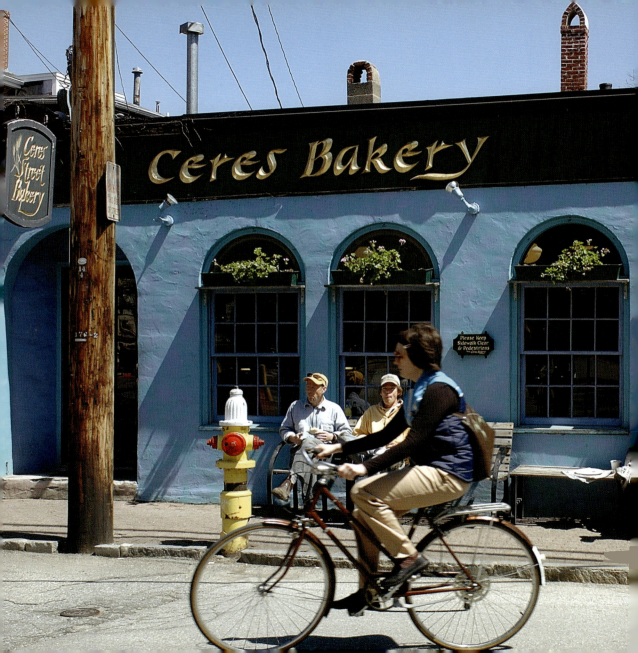

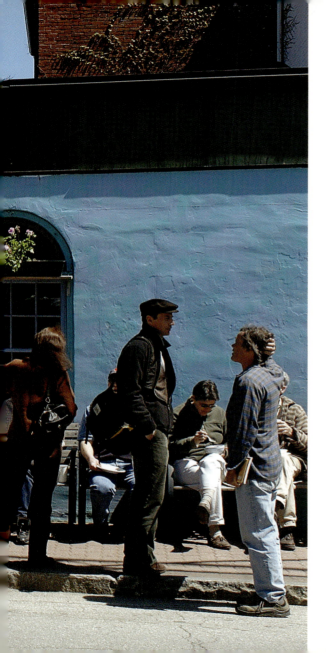

(*overleaf*) Boating on back channel of river

Ceres Bakery, a local hangout on Penhallow Street

WE NEVER HAD TO LEAVE DANIEL STREET
for anything. We had bakeries, grocery stores,
creameries, drug stores, restaurants, beer joints.
There was parking on both sides of the street,
two-way traffic and brick sidewalks, too.
I didn't like the brick sidewalk because it
made riding my bike difficult.

—John Russo, proprietor, John's Barber Shop

Daniel Street signs including one for the world-famous Press Room

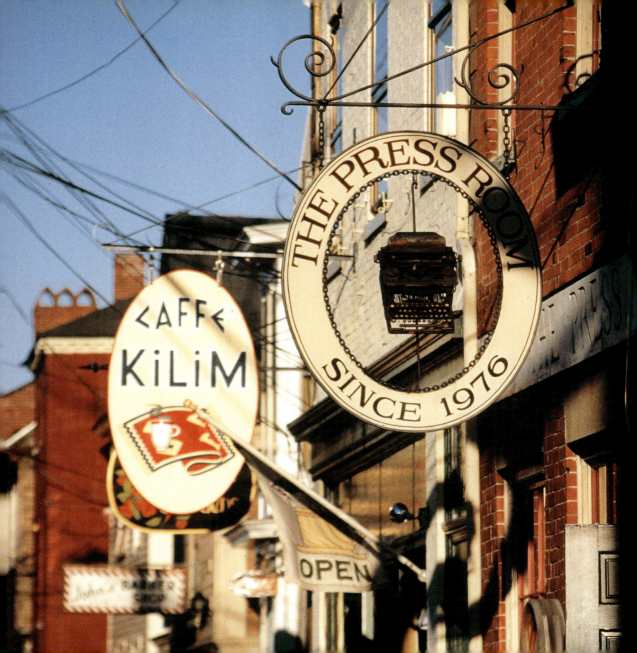

IN THIS OLD TOWN MEN MADE FAMOUS
By their deeds in days of yore,
There are now Colonial dwellings
With hip-roofs and panelled doors.
These old homes, grand and historic,
Still their owners' names retain,
And we oft by retrospection
See them living there again.

— Clara A Lynn,
 from "Portsmouth's Ancient Dwellings," 1929

Three centuries of architecture on view at Strawbery Banke Museum

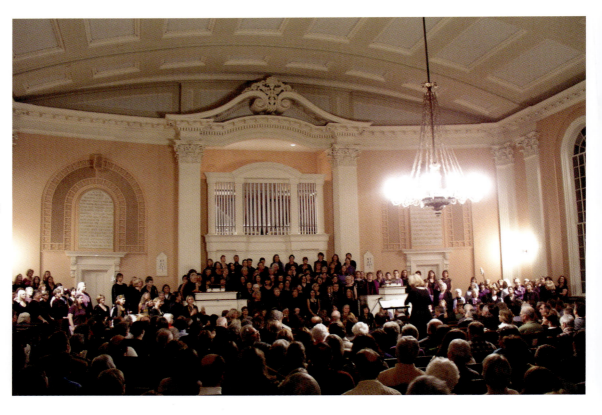

(*overleaf*) White Island Light at the Isles of Shoals signals the entrance to Portsmouth Harbor

THE UNIVERSALIST SOCIETY WAS ORGANIZED in Portsmouth in 1777. . . . The first meetinghouse for the society was on Vaughan Street. [Another] church was built in 1807 and was among the finest buildings in the town. It burned on March 28, 1896, and was replaced by the brick Universalist Church. For much of the nineteenth century this congregation was the largest in Portsmouth.

—Robert C. Gilmore and Bruce E. Ingmire,
 The Seacoast, New Hampshire: A Visual History, 1980

The Universalist-Unitarian church and the Voices from the Heart choir

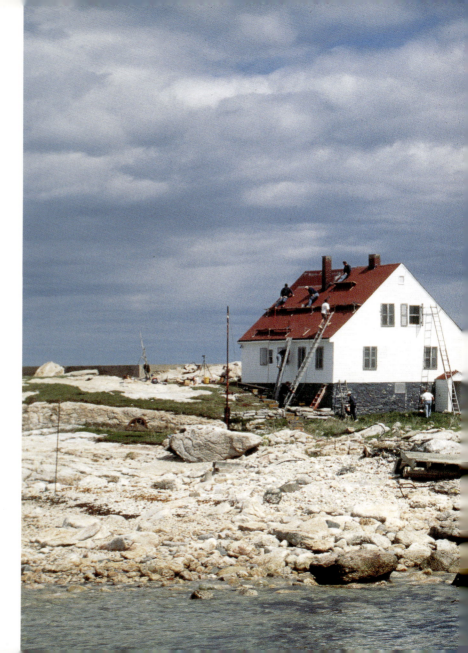

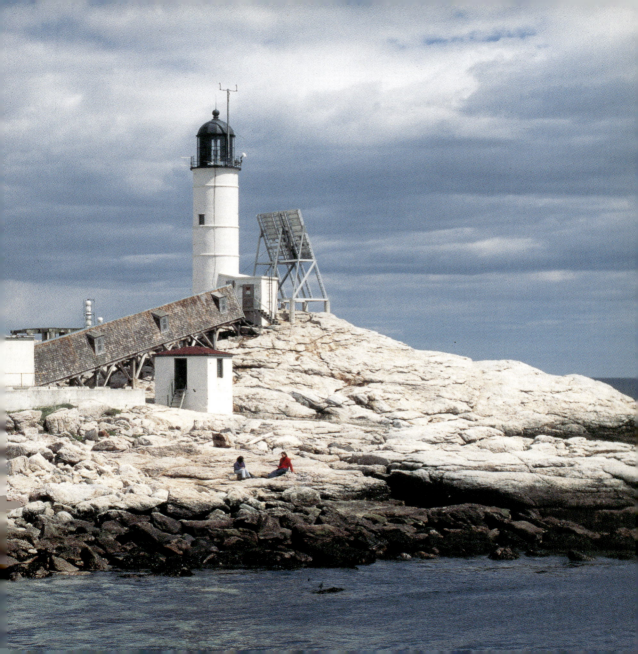

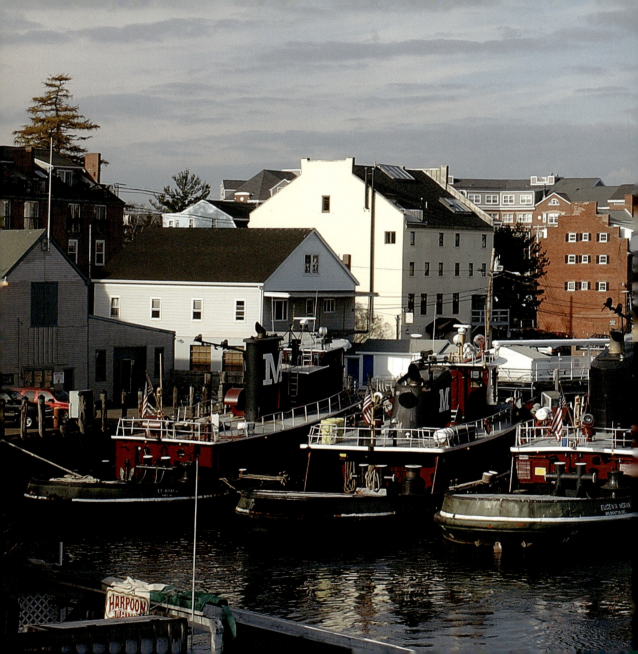

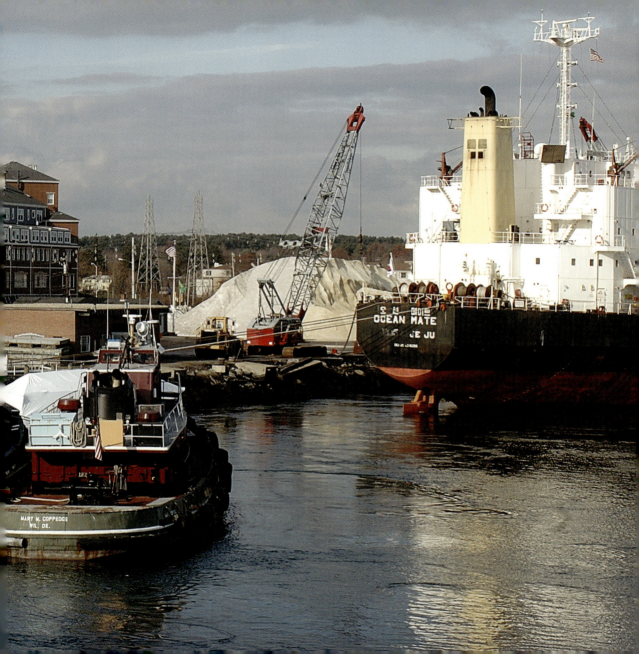

(*overleaf*) Tug boats on Ceres Street with salt ship, salt pile and Sheraton Hotel in background

Market Square with the North Church in winter

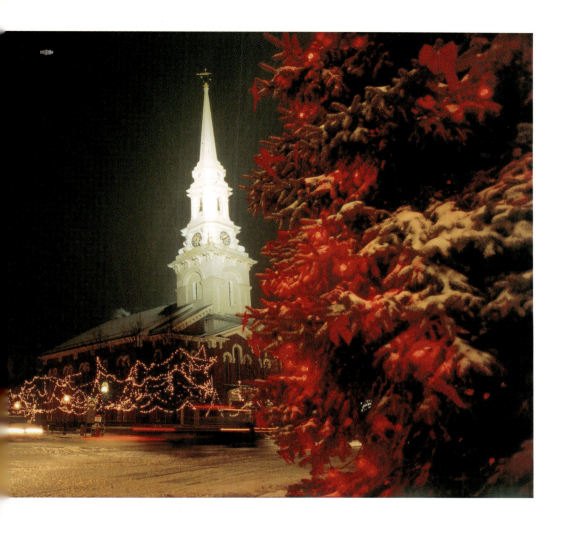

RICH IS THE HERITAGE LEFT TO US AND OUR CHILDREN who live among the Isles and the river Piscataqua, left by dreamers who lived where the lie of the land held their imagination, with its cluster of islands standing sentinel over a river's mouth which led far inland through a lace work of waterways, into a rich and fertile land.

—Robert H. Whittaker, *Land of Lost Content*, 1993

Strawbery Banke Museum role players

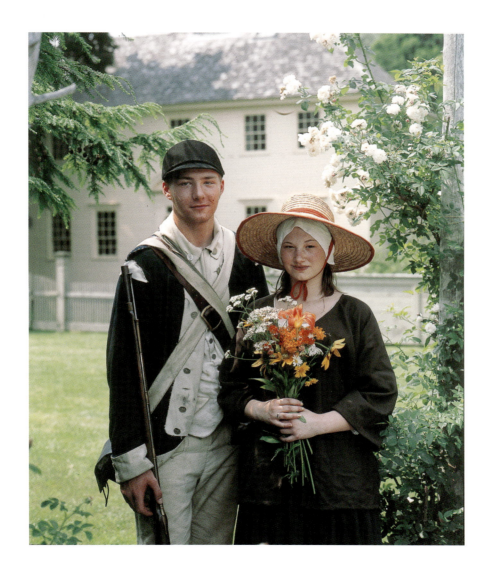

ACKNOWLEDGMENTS

Portsmouth would never have come about without the inspiring beauty of the river city and the unique character of its residents. My career as a photographer has taken me to many wonderful places all around the world and I have chosen Portsmouth to be my home. The constant changes make it a tremendously appealing and energized place to live and to work and to photograph.

 I want to thank Webster Bull and Perry McIntosh for helping me create this project. I owe a special debt of thanks to writer Laura Pope for her insight and energy in helping this creation happen. Finally, my abiding affection to my mother, Grace E. Horton, for supporting my perpetual wanderlust.

Photo by Kim Case

NANCY GRACE HORTON has been a resident of Portsmouth, New Hampshire, for most of her adult life. She has traveled the world taking photographs and her images have appeared in numerous national and international publications and exhibitions. Her web site, www.hortonphoto.com, includes updates of her latest photographic expeditions.

LAURA POPE is a magazine and newspaper journalist specializing in culture and history. She also writes plays, the most recent devoted to the imagined life and times of celebrated 19th century Portsmouth tycoon, Frank Jones.

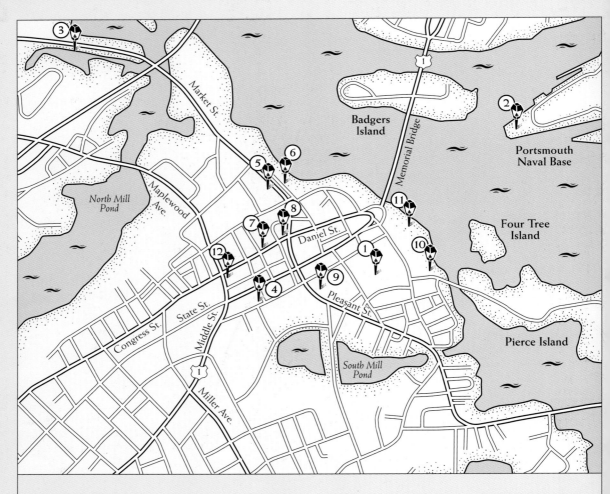

1. Strawbery Banke
2. Portsmouth Naval Yard
3. Albacore Park
4. The Music Hall
5. Ceres Street
6. Moran Tugboats
7. Market Square
8. North Church
9. Gov. John Langdon House
10. Prescott Park
11. Sheafe Warehouse
12. John Paul Jones House